Crocus

A Photo Essay

by

Stephen M Kraemer

© 2019 Stephen M. Kraemer

Originality

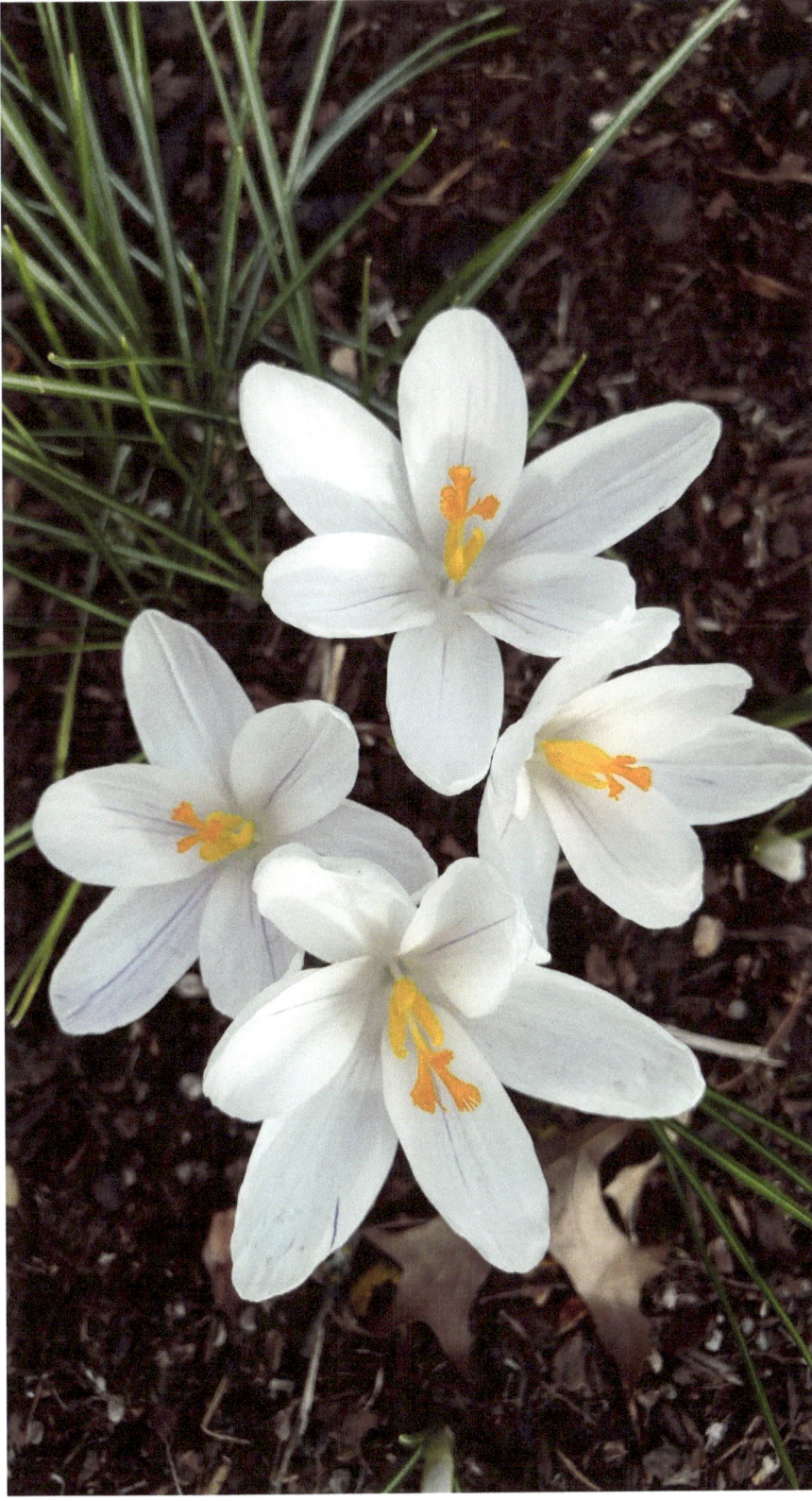

Winter Light

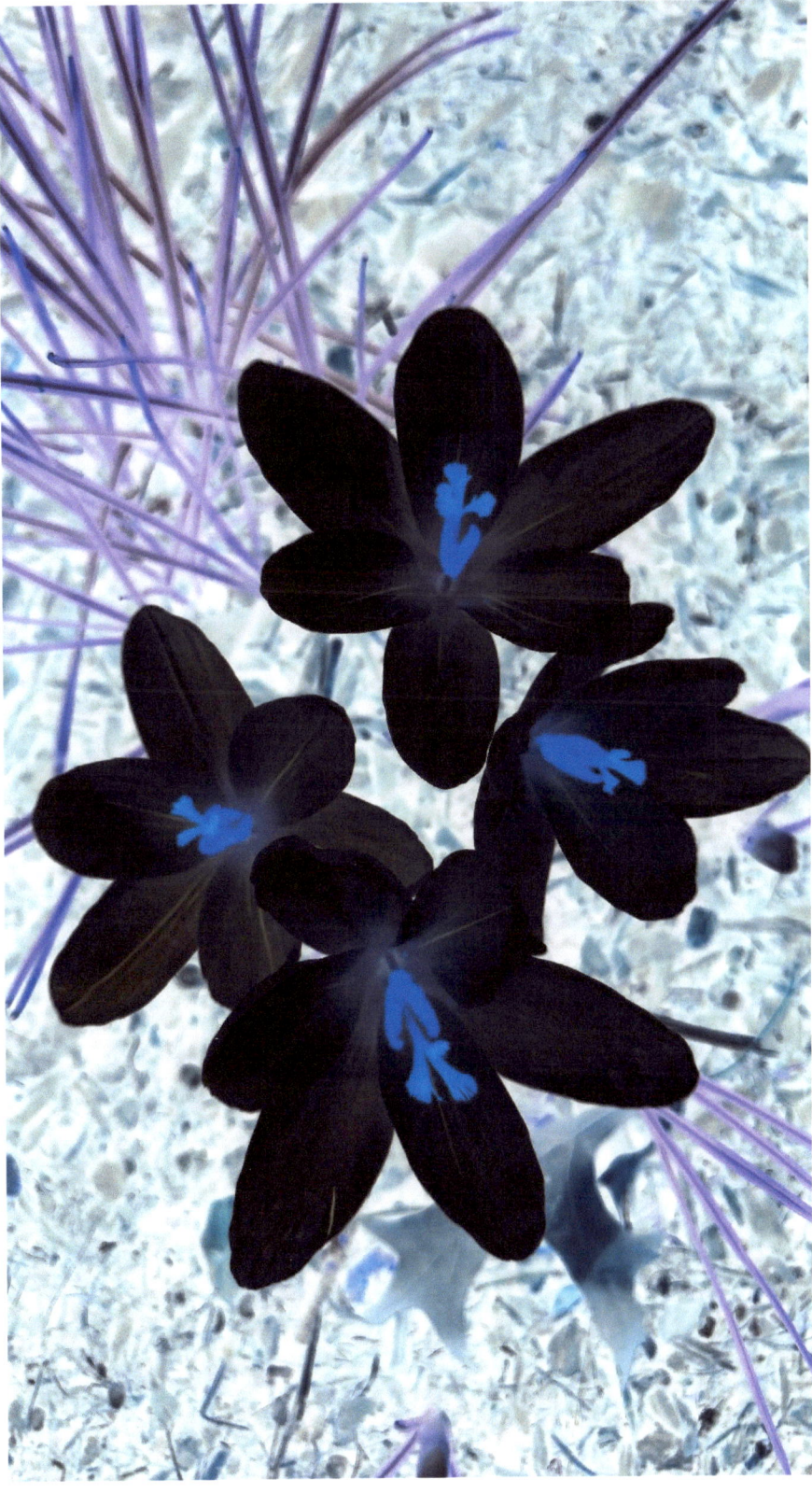

Palettes

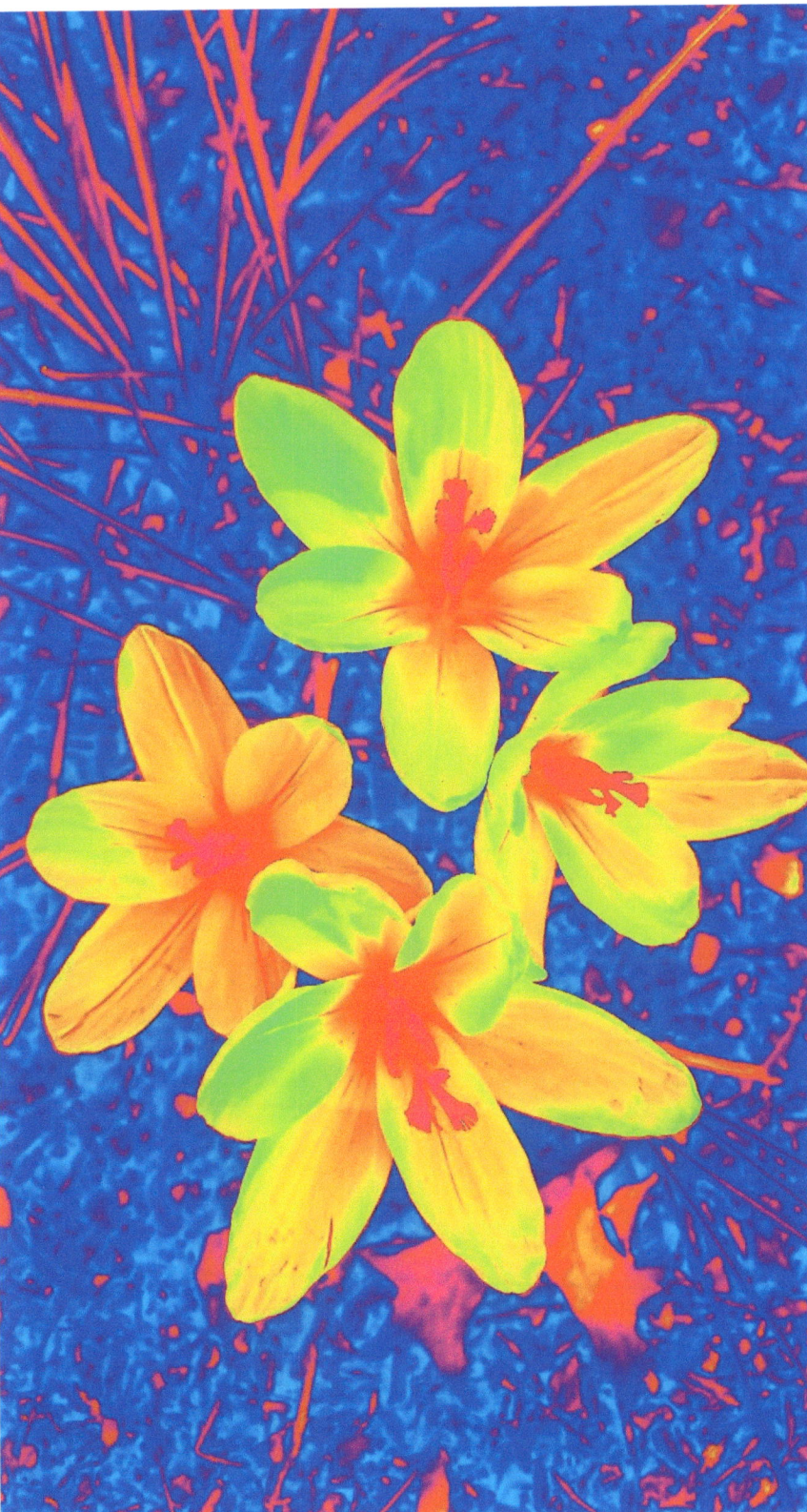

Enchanted Hours

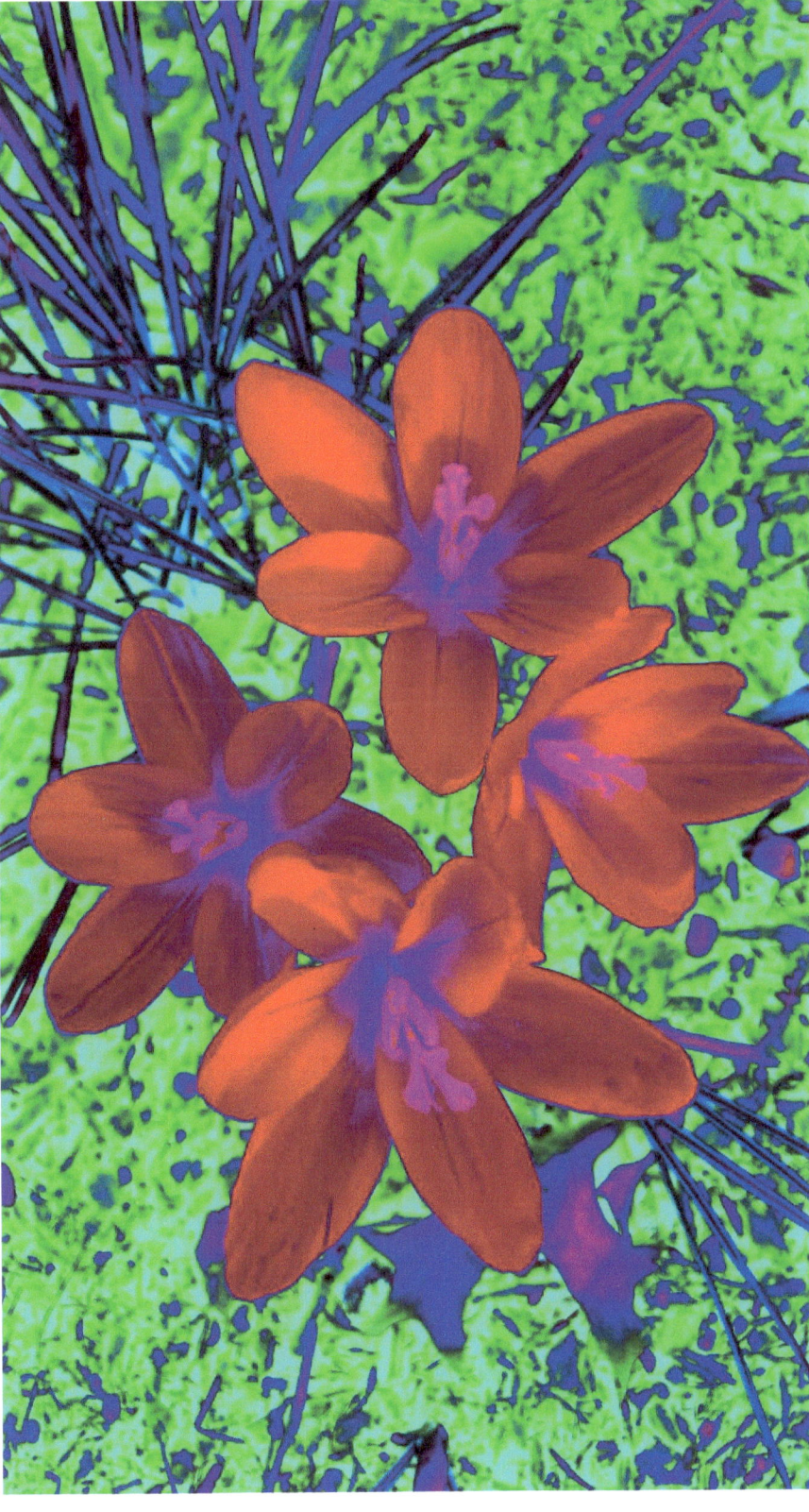

Regalia

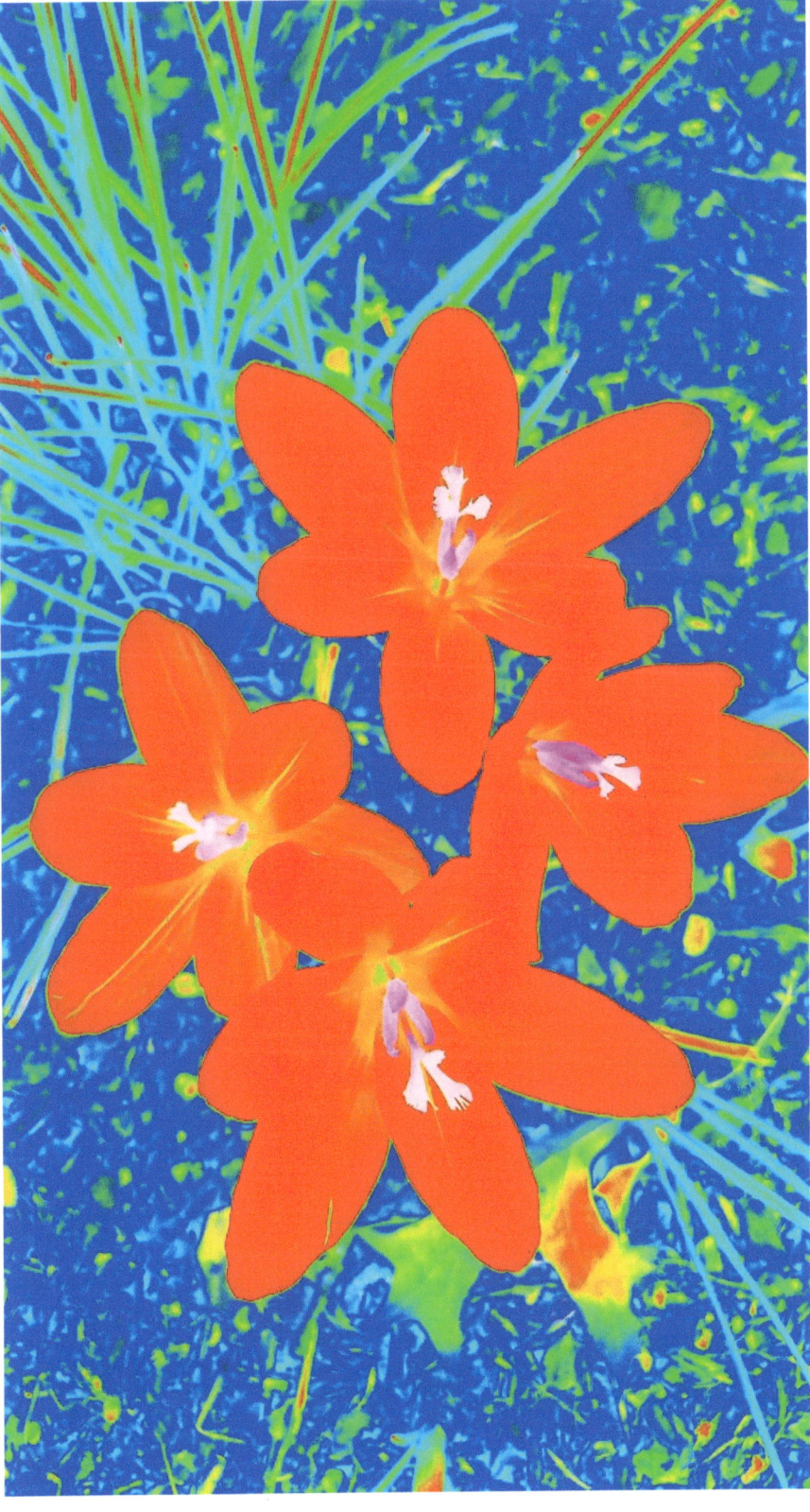

Sesquicentennial

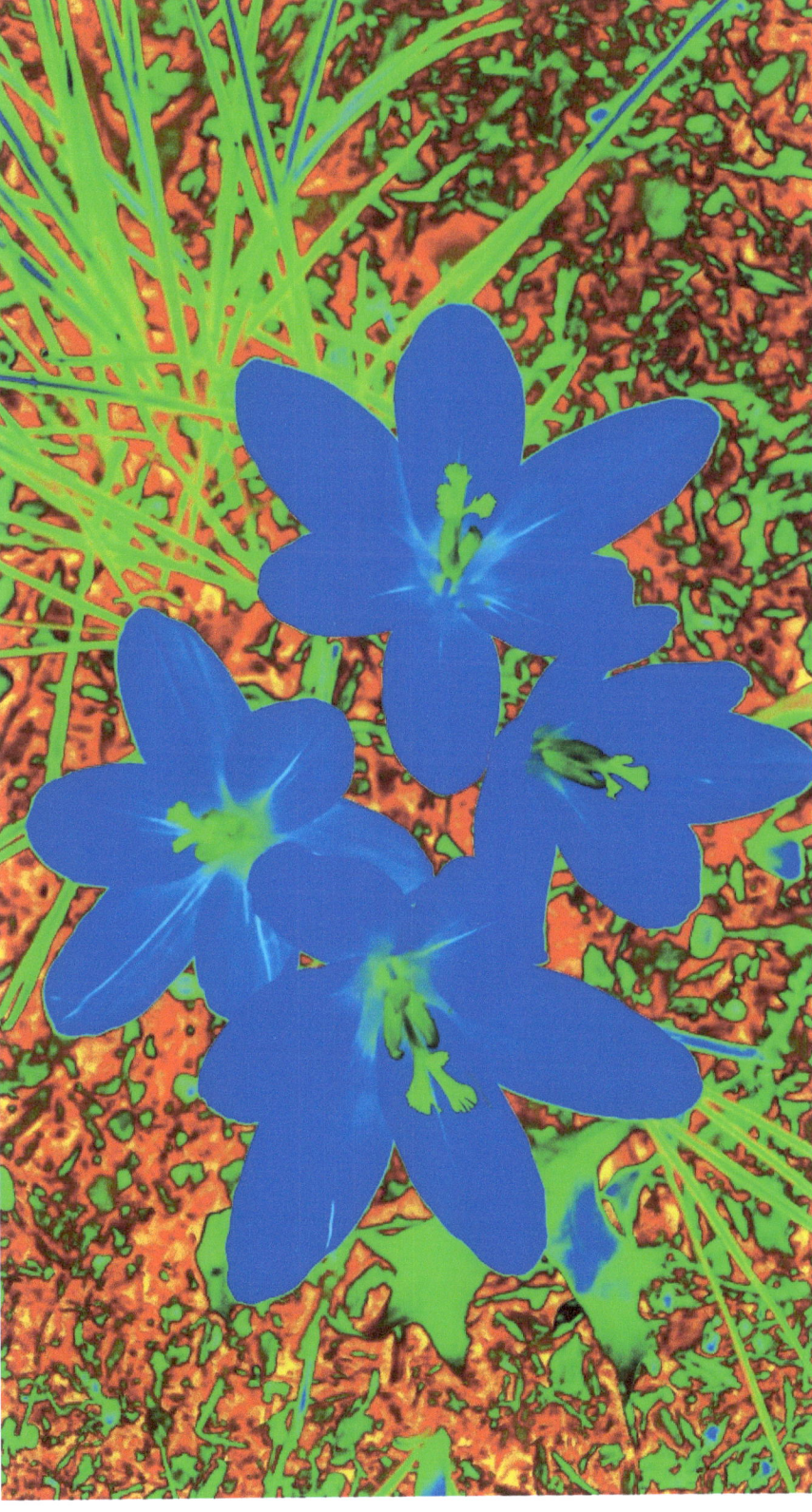

Collaboration

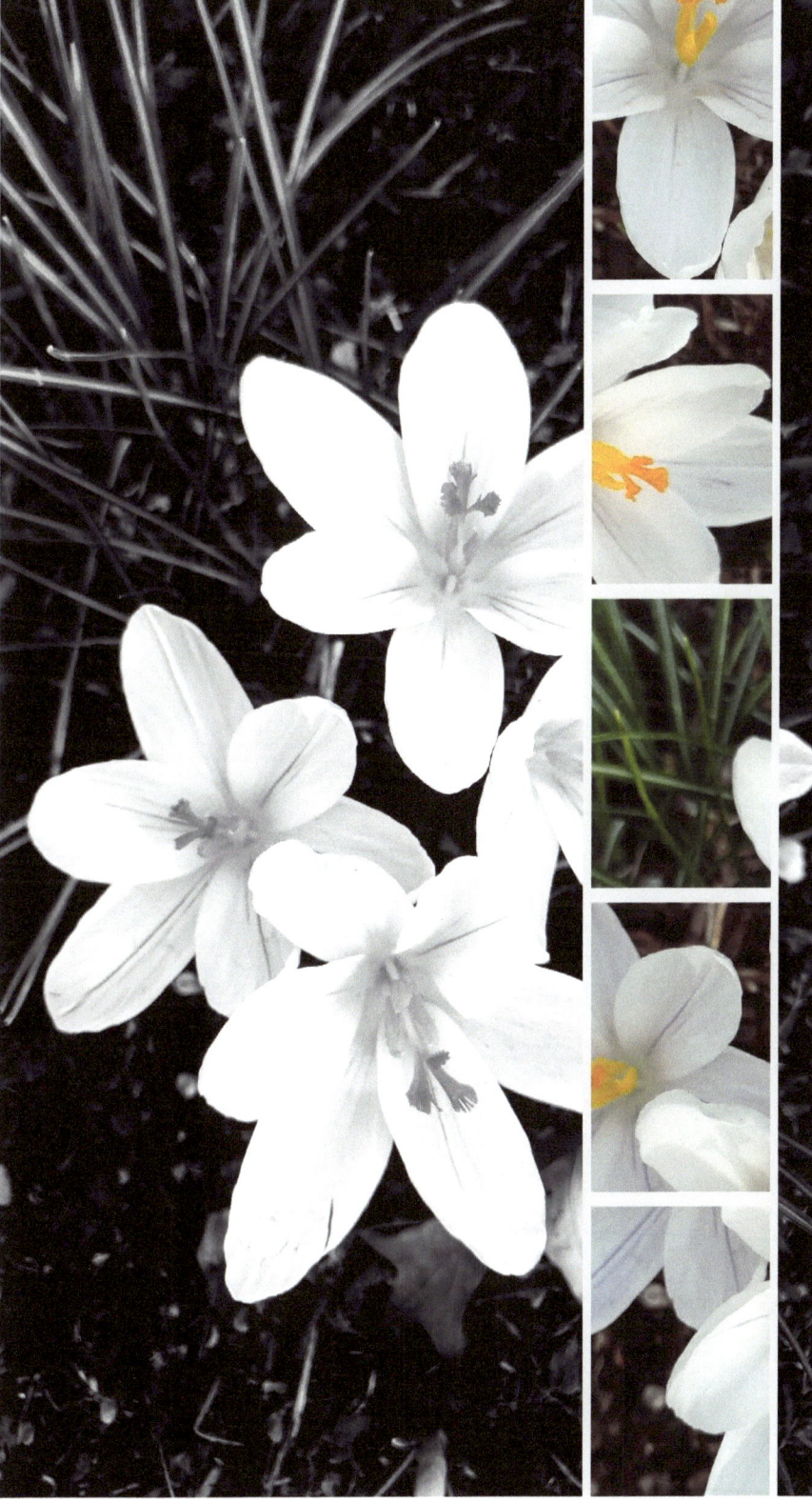

Standout

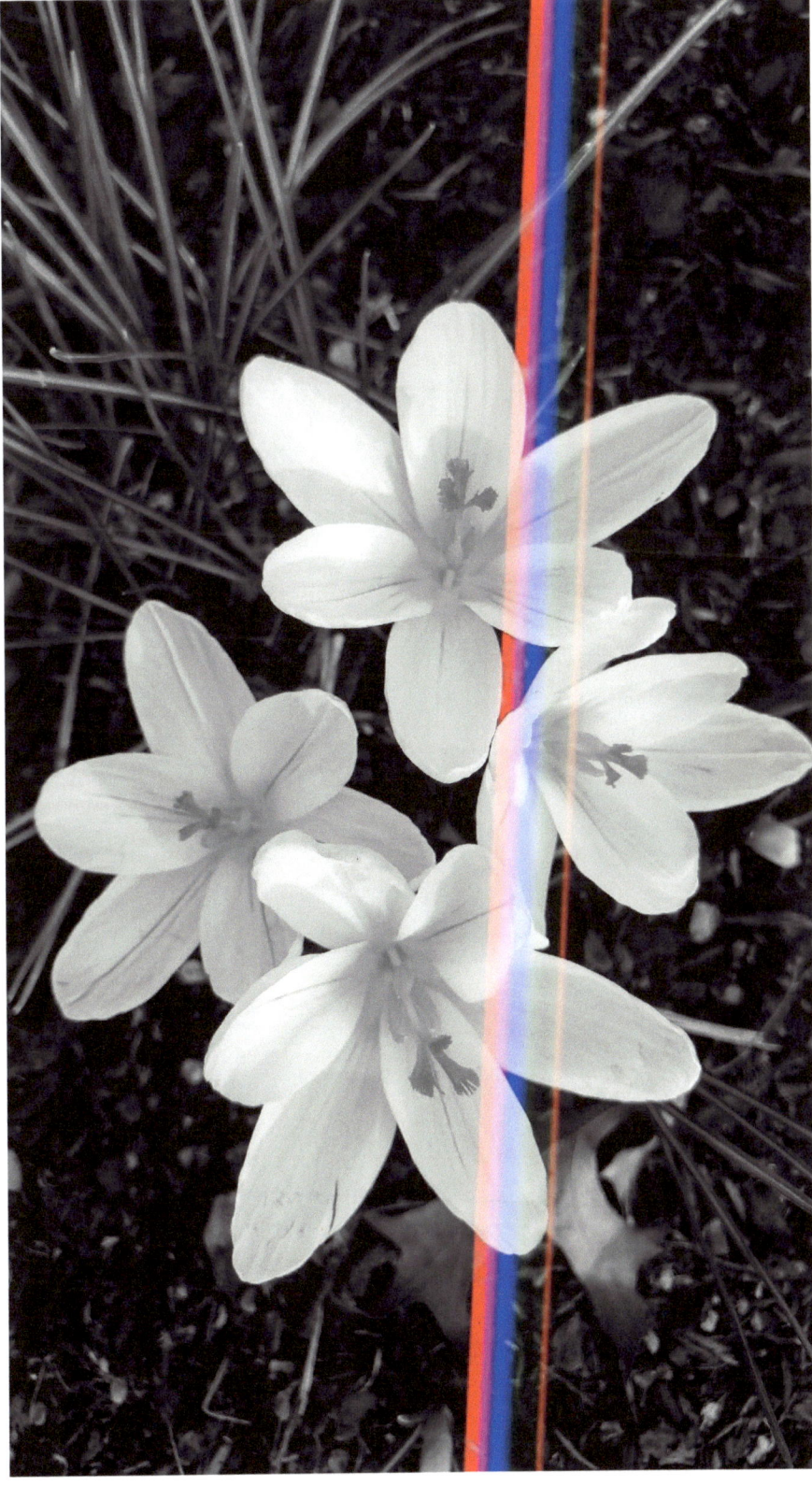

Nature's Way

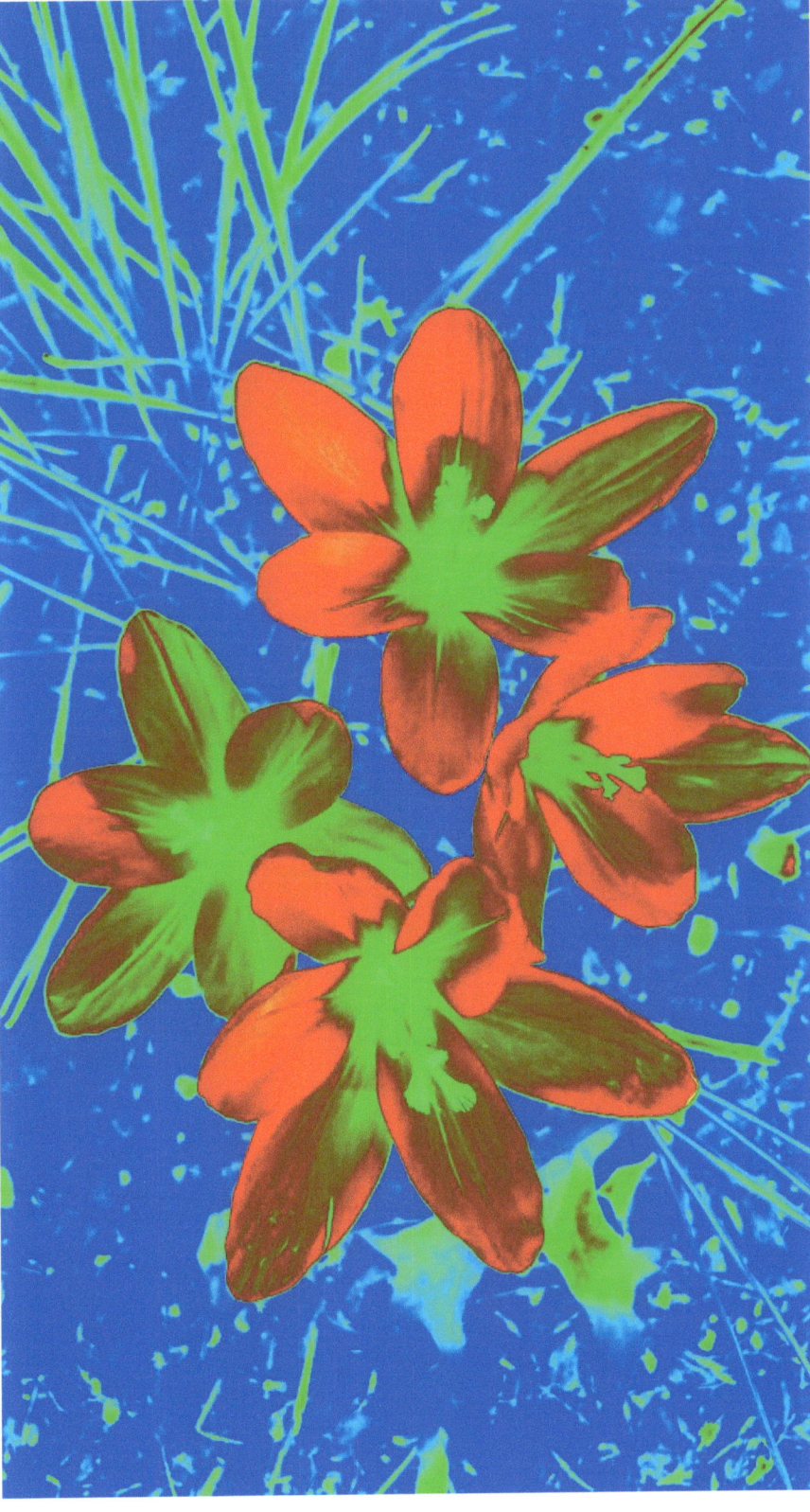

Lightning

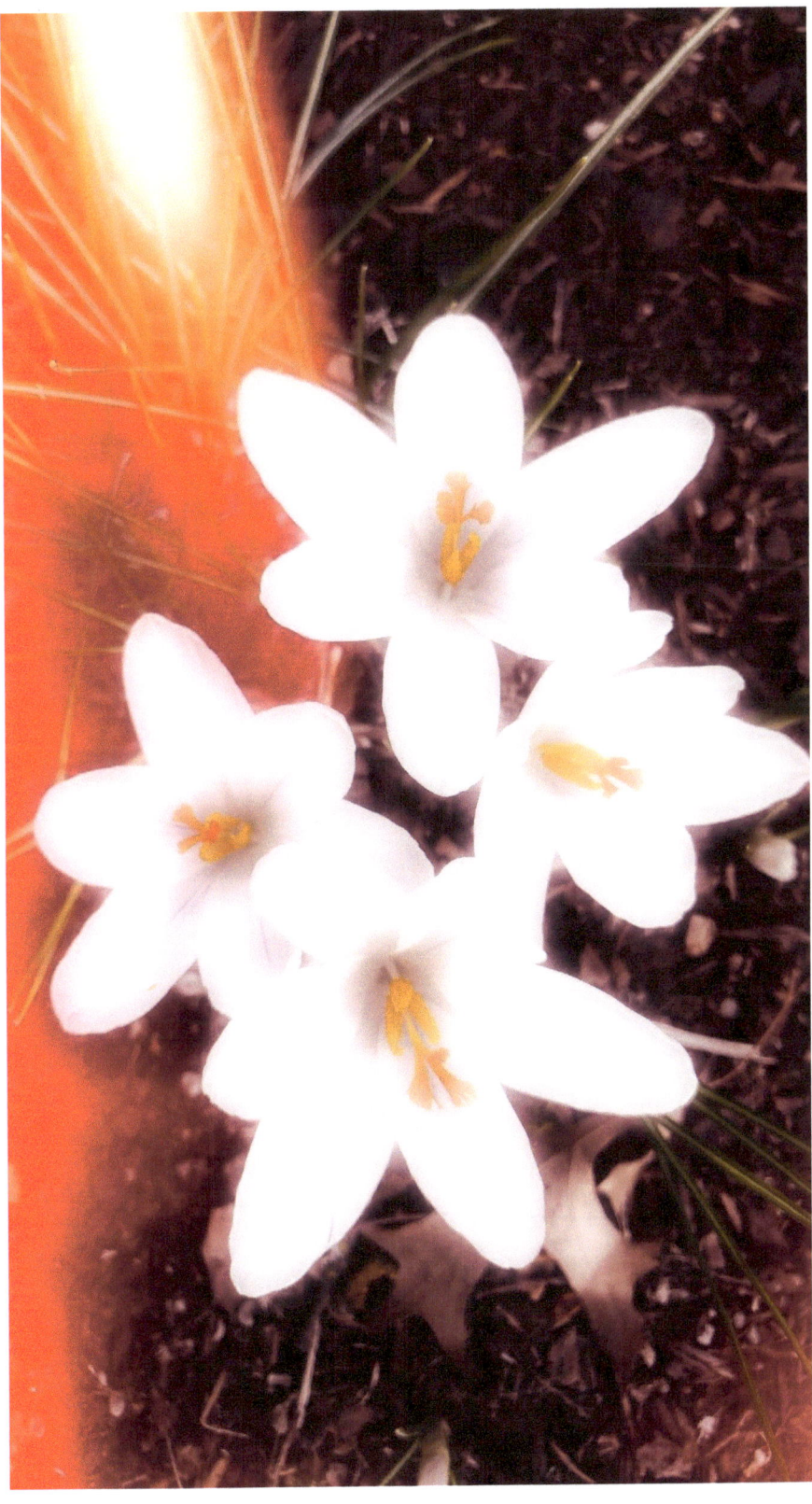

Temptation

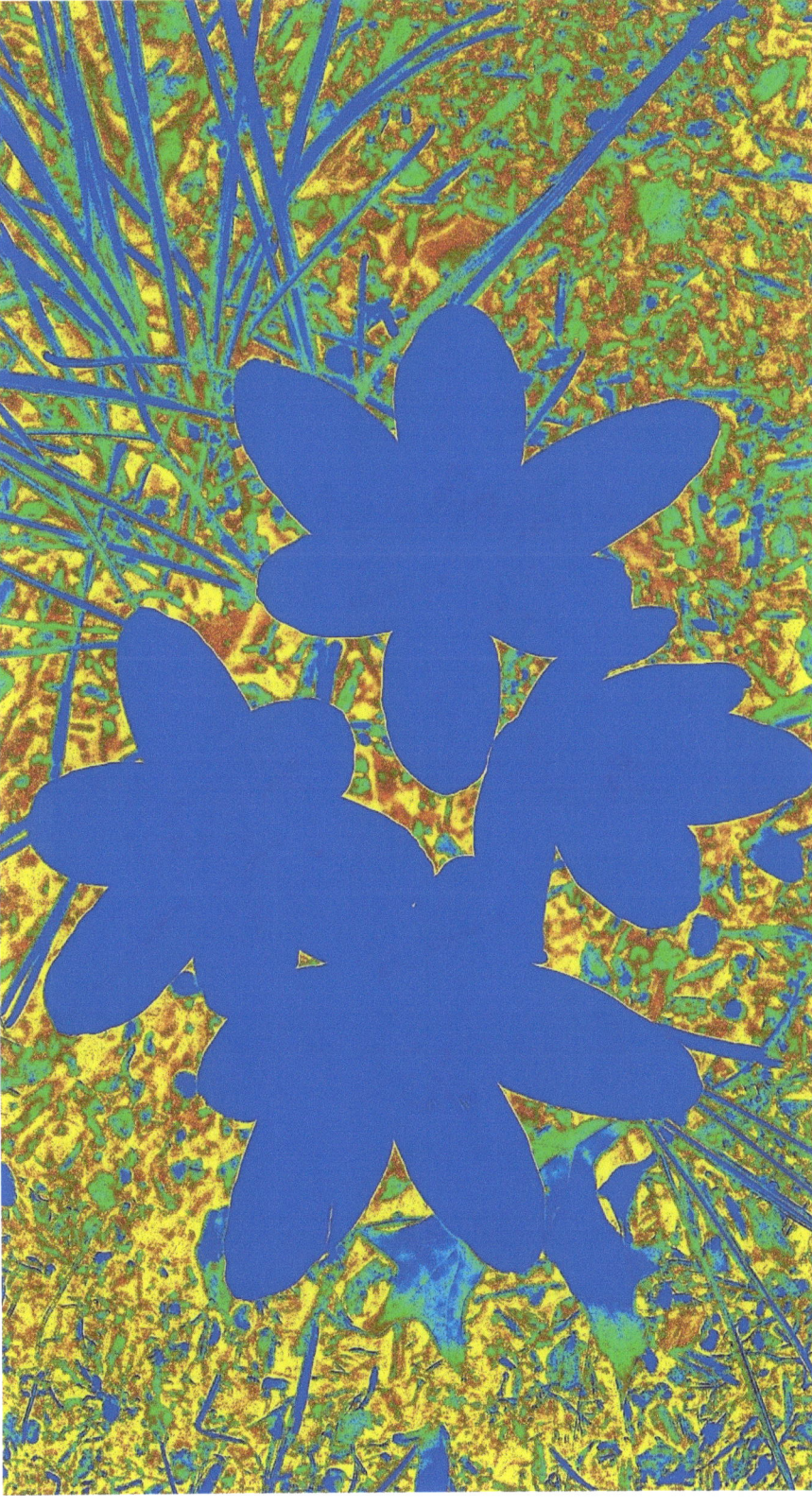

Orchestral

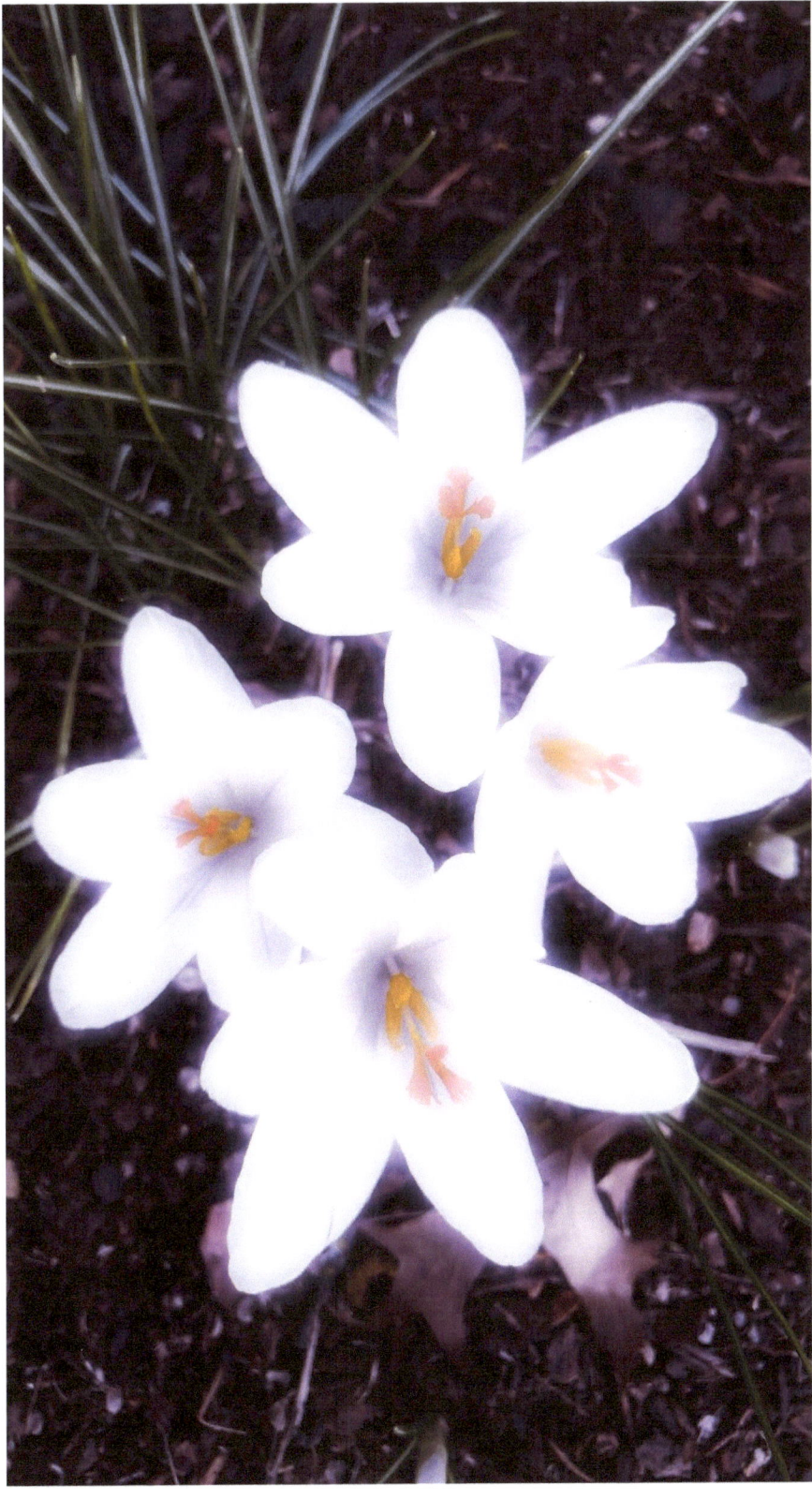

Reflectivity

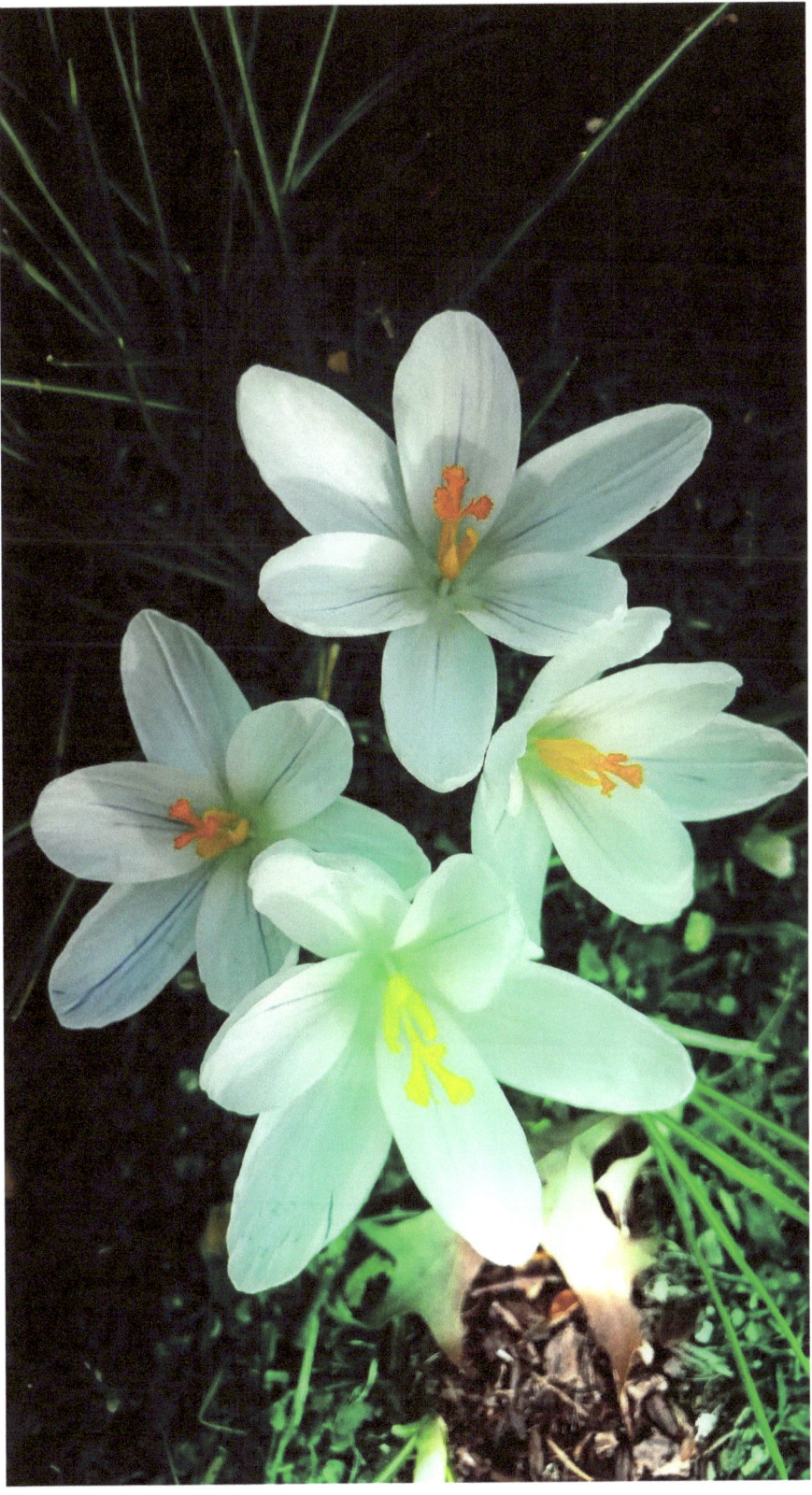

Golden Rainbow

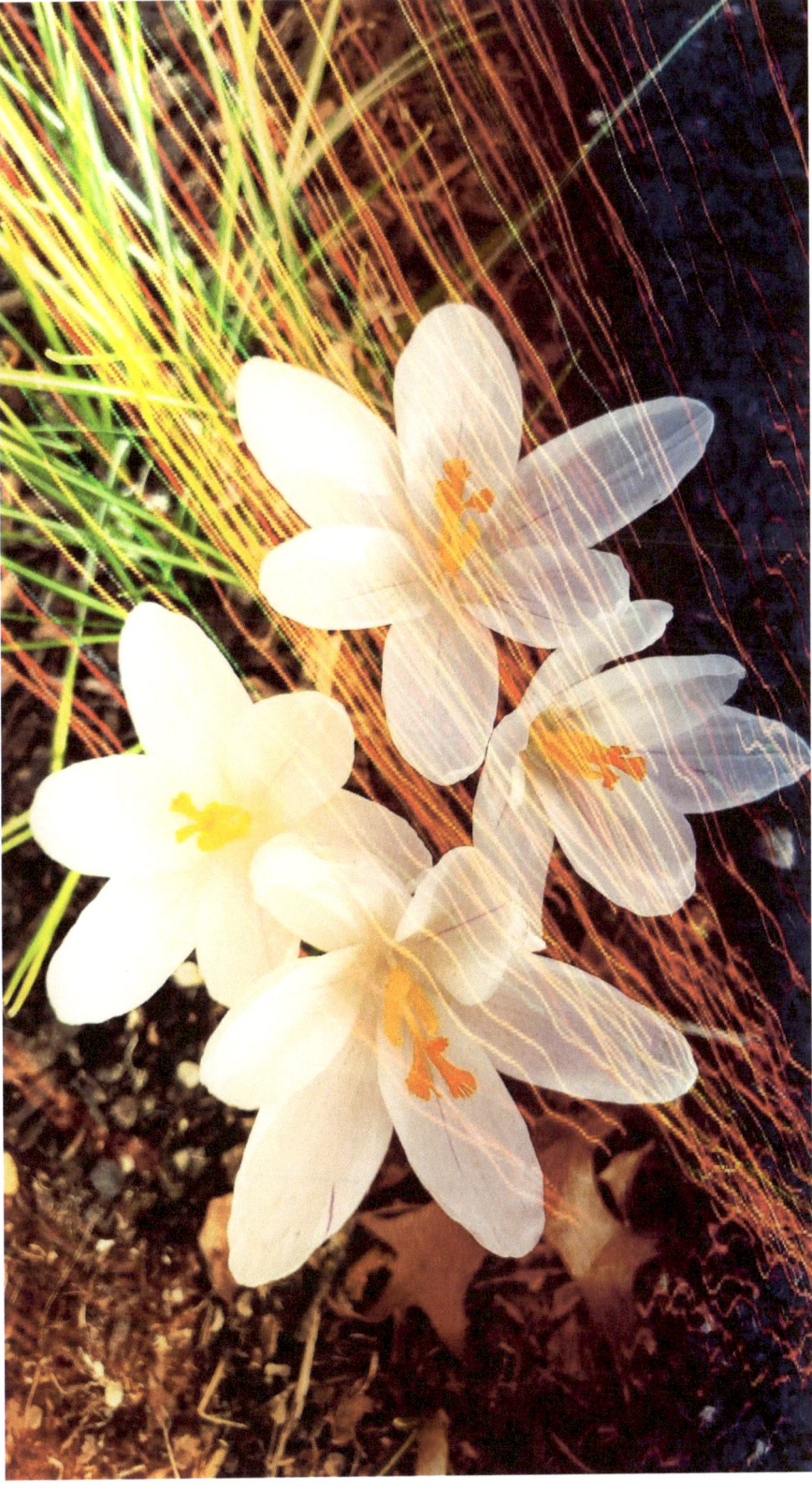

Reductions

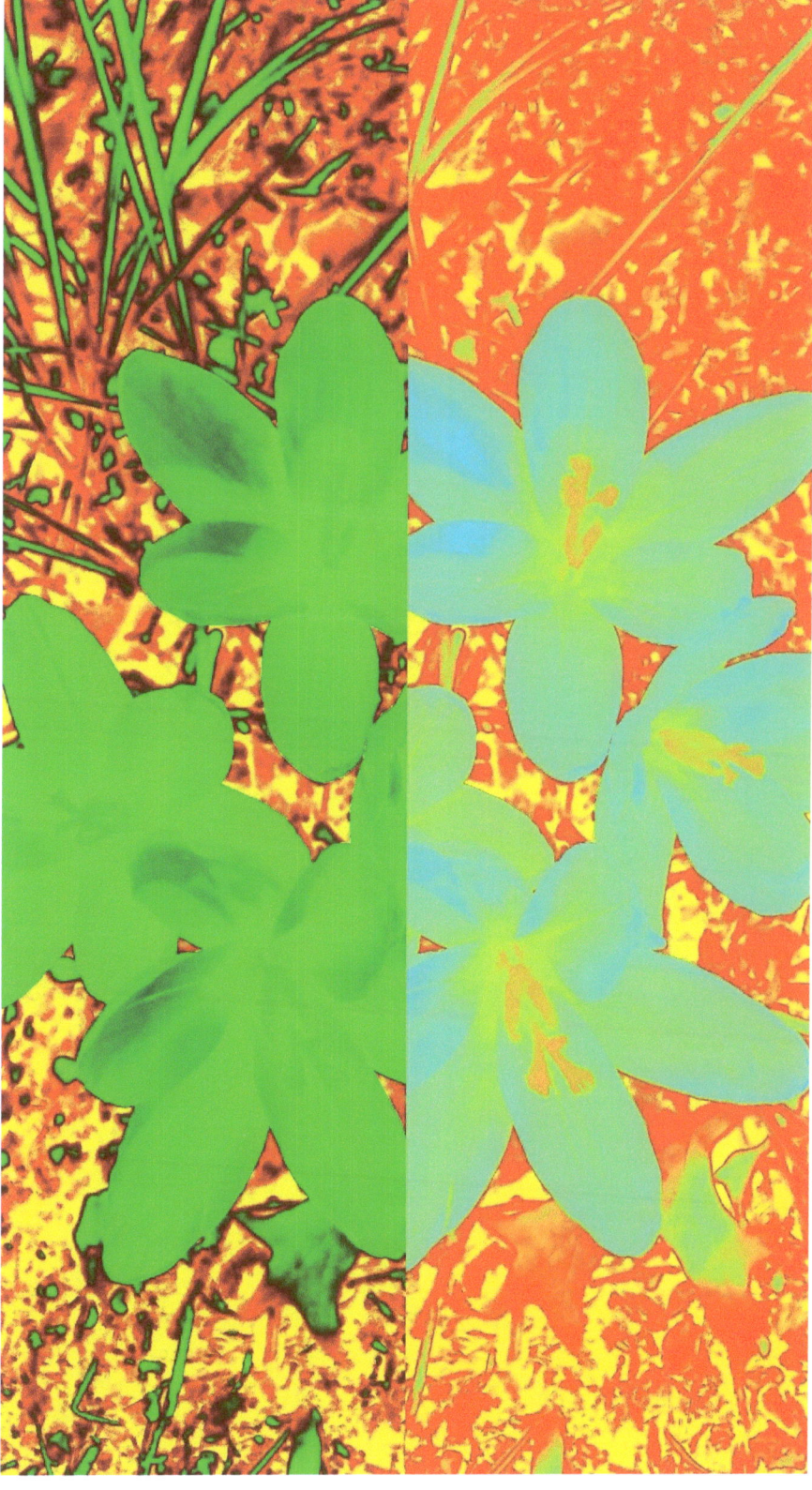

Softer Tones

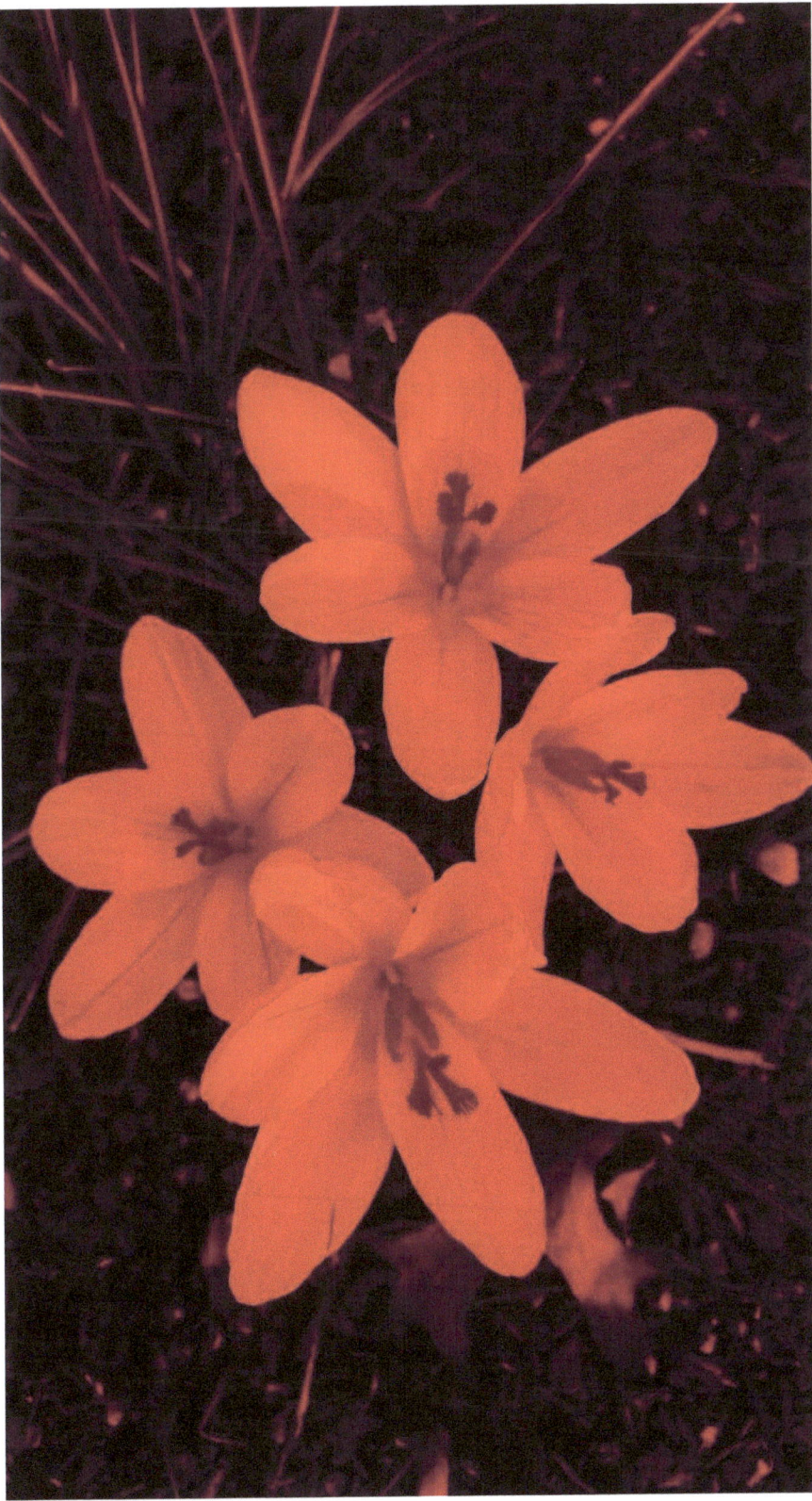

Perplexed

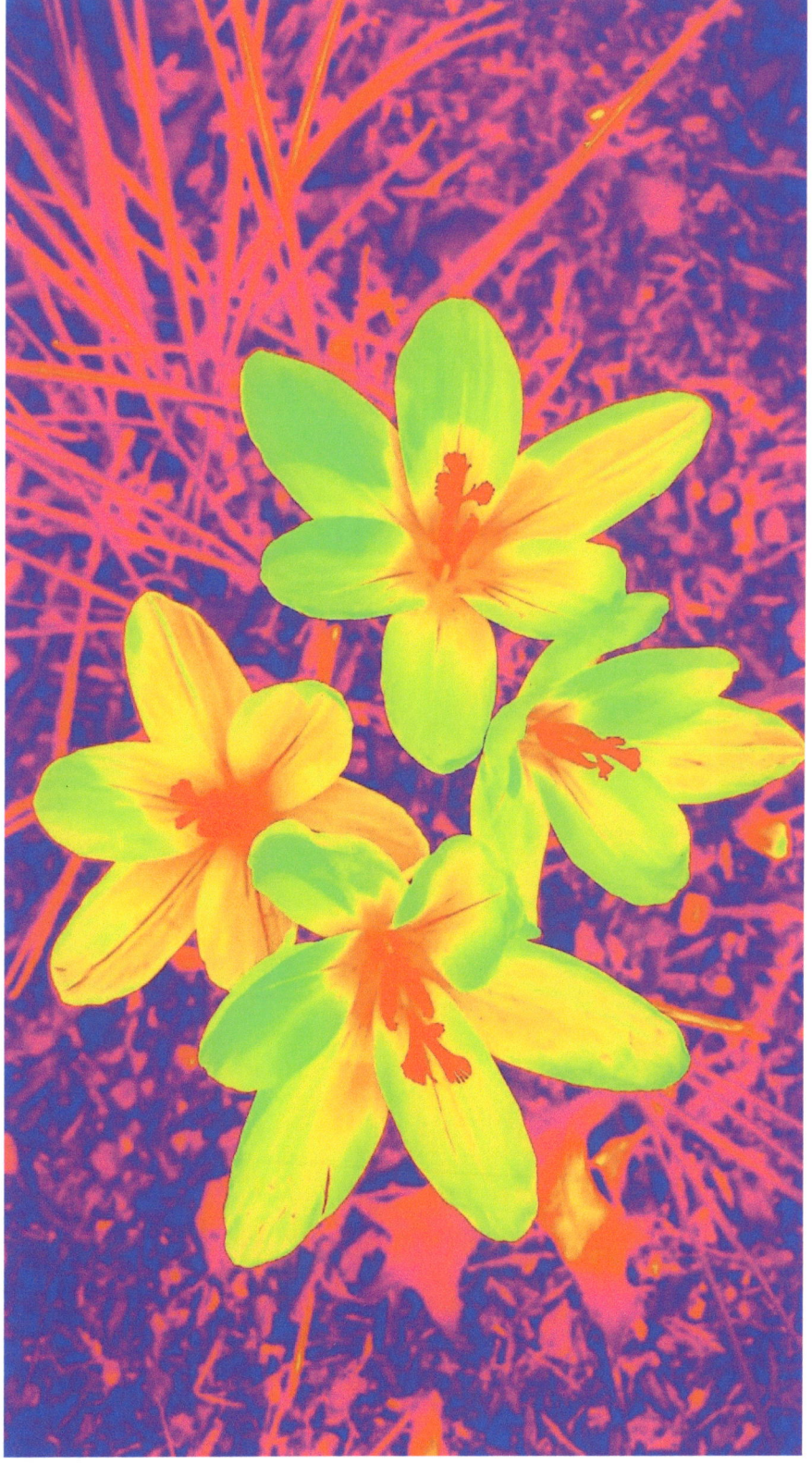

Lit up

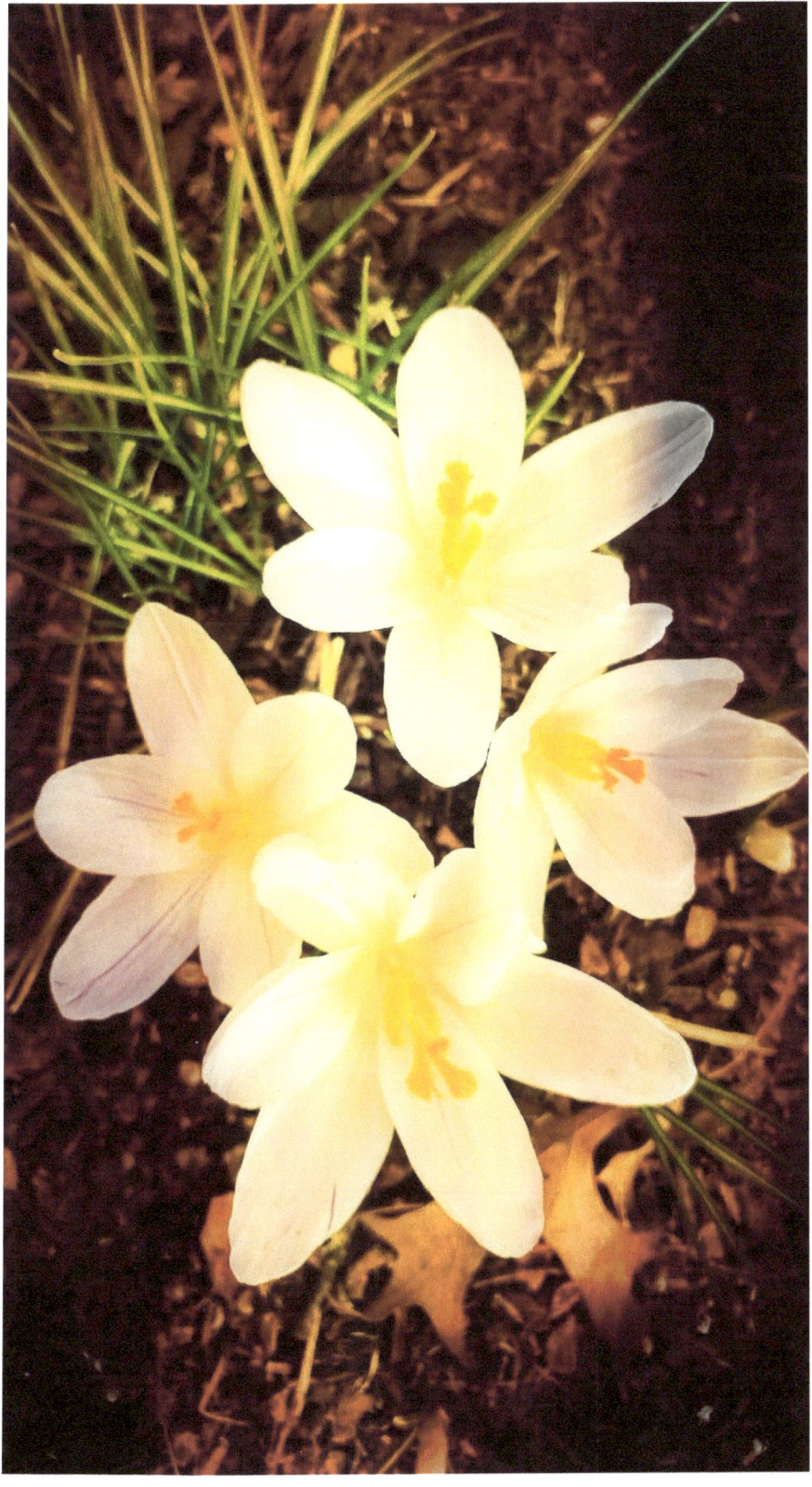

Medallion

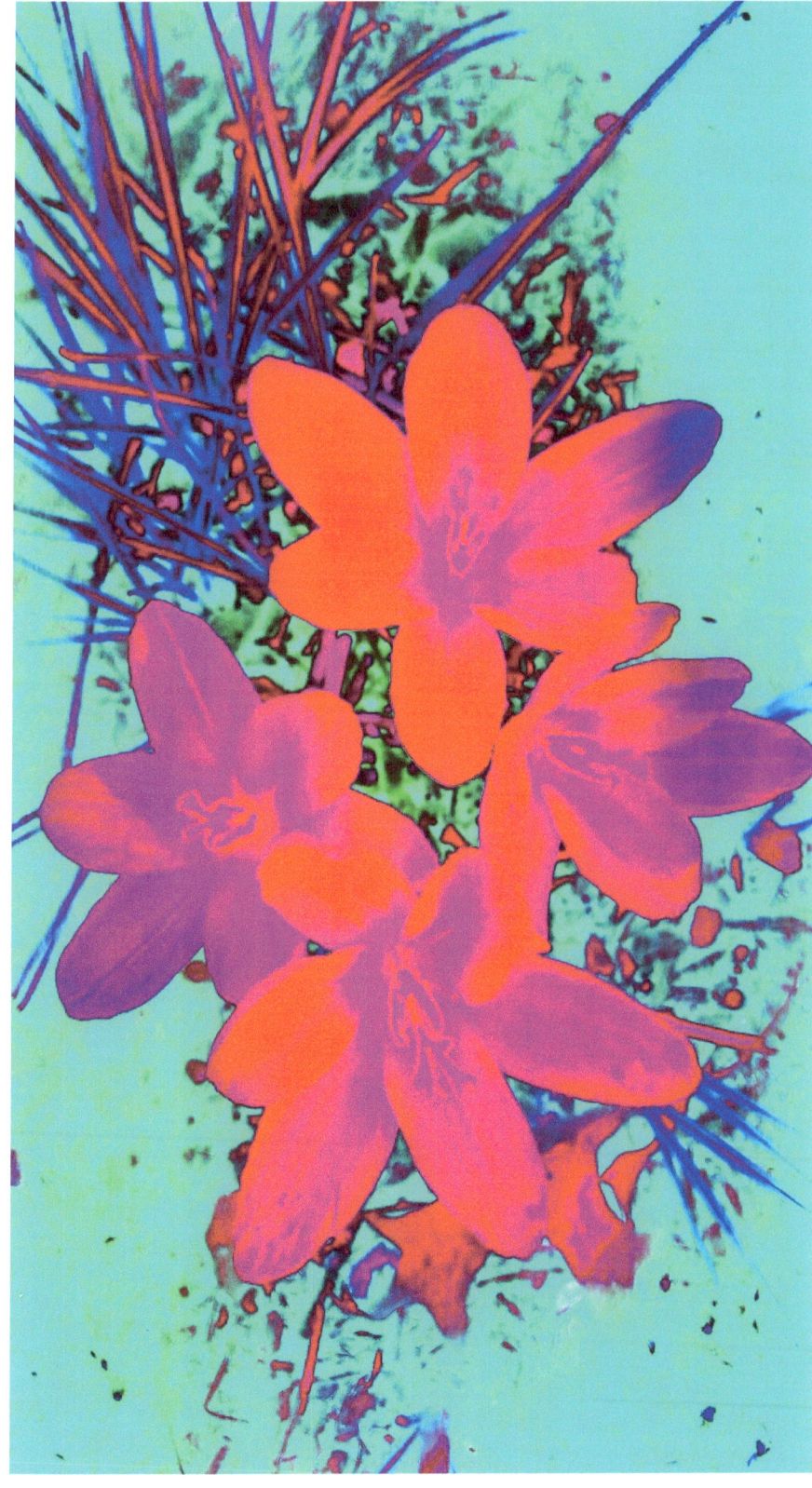

www.ingramcontent.com/pod-product-compliance
Lightning Source LLC
Chambersburg PA
CBHW041115180526
45172CB00001B/254